It's Summer

by
Jimmy Pickering

smallfell⊙w press
LOS ANGELES

To Sheri and Tote (Sharon)

Thank you for making our Summers together
one fun adventure after another!

Sally and Sam are delighted to see
A Summery morning as clear as can be.

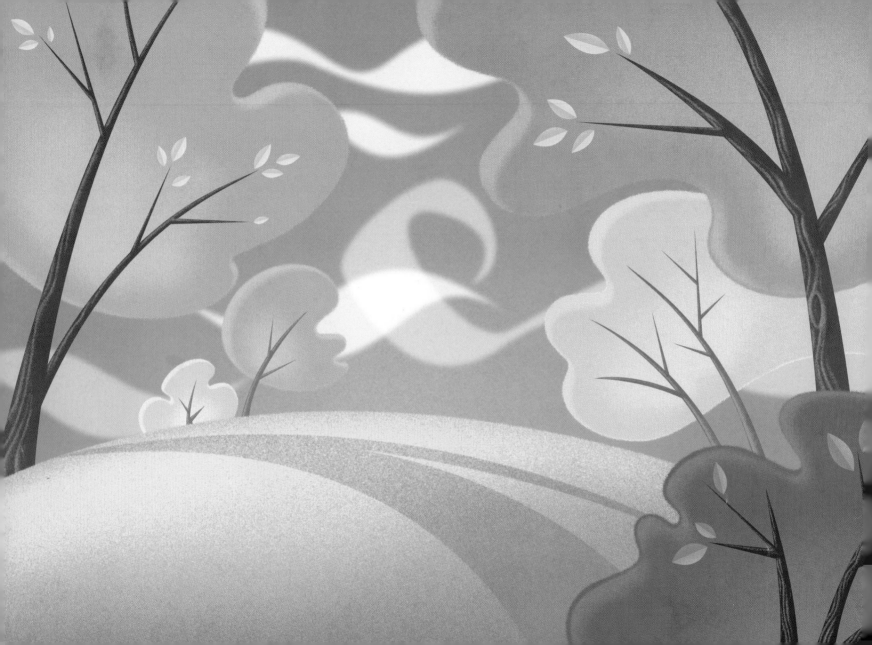

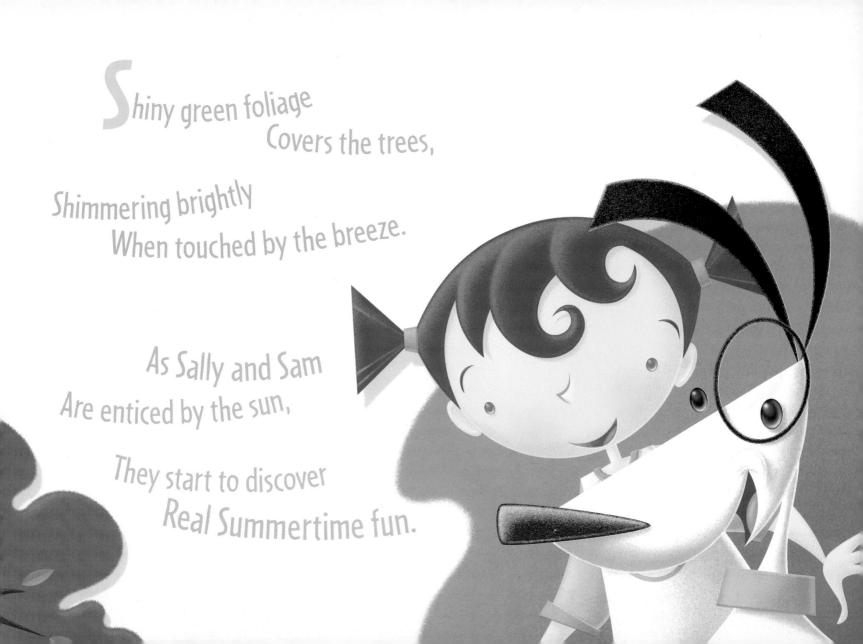

Shiny green foliage
Covers the trees,

Shimmering brightly
When touched by the breeze.

As Sally and Sam
Are enticed by the sun,

They start to discover
Real Summertime fun.

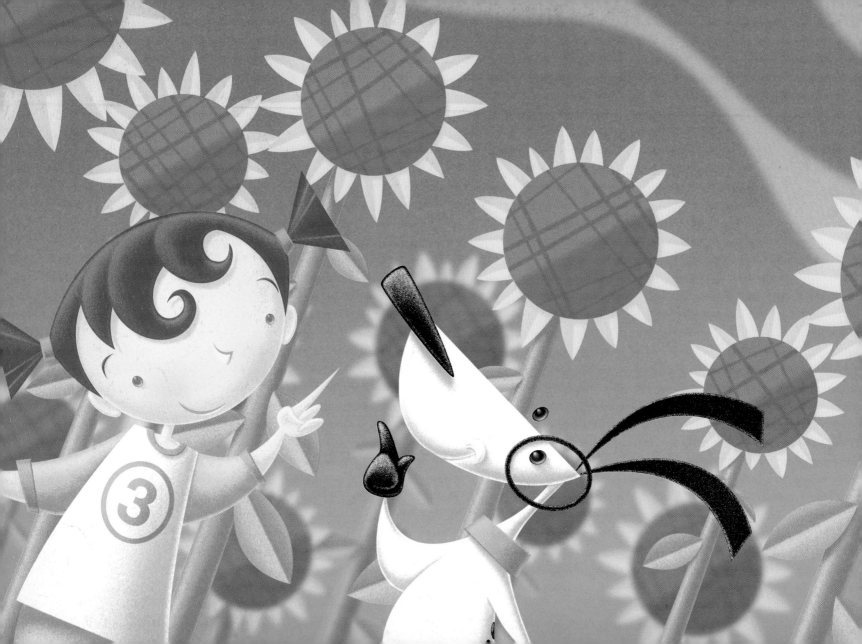

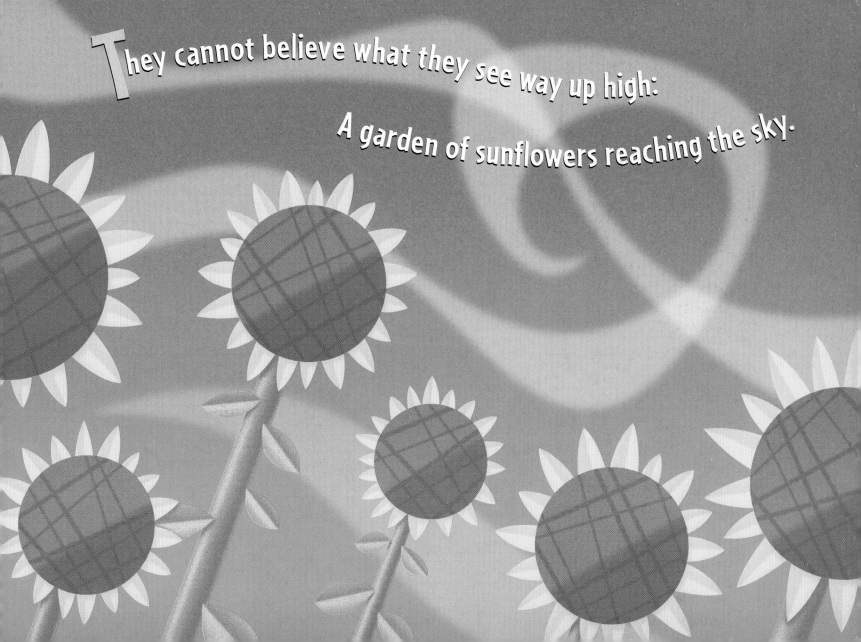

They cannot believe what they see way up high:

A garden of sunflowers reaching the sky.

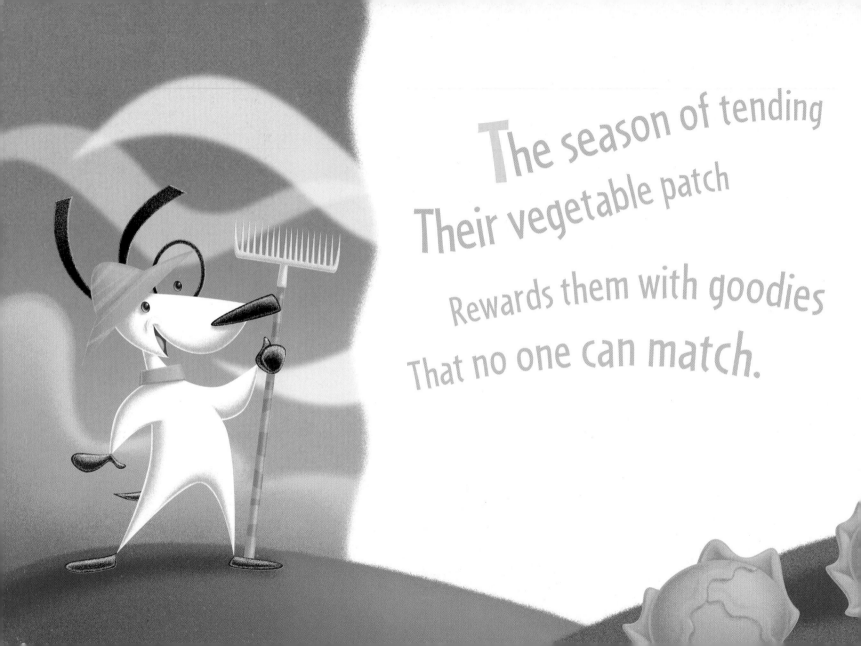

The season of tending
Their vegetable patch

Rewards them with goodies
That no one can match.

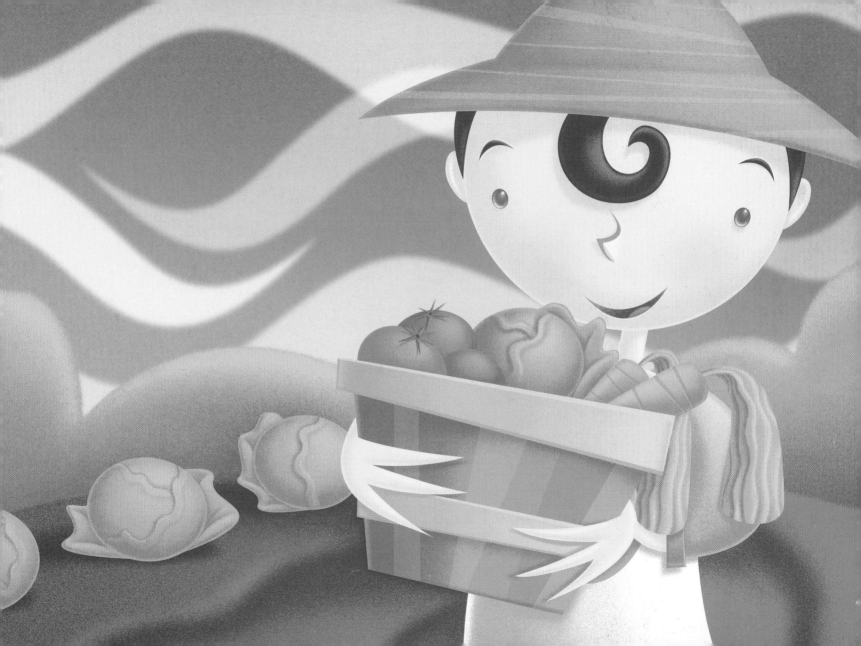

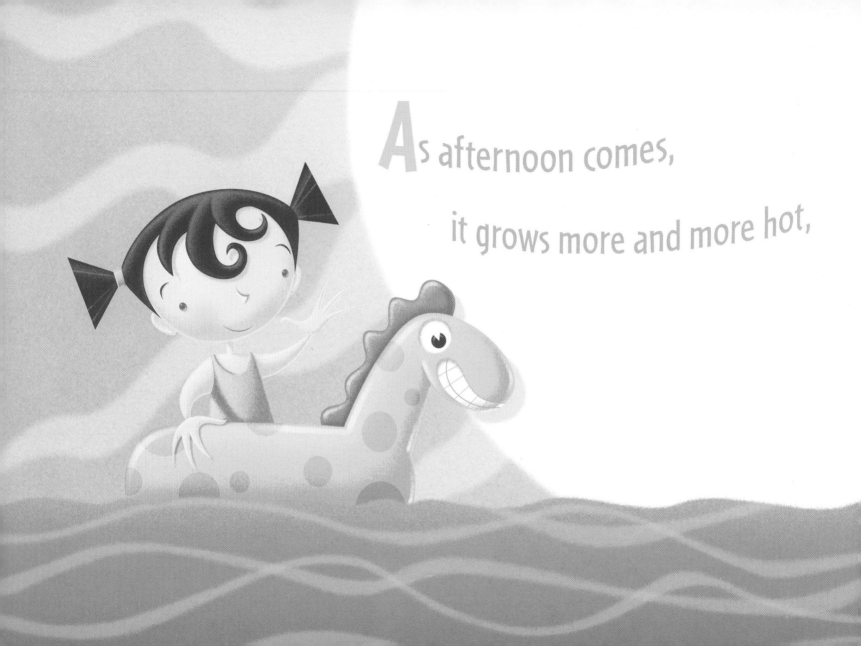

As afternoon comes,

it grows more and more hot,

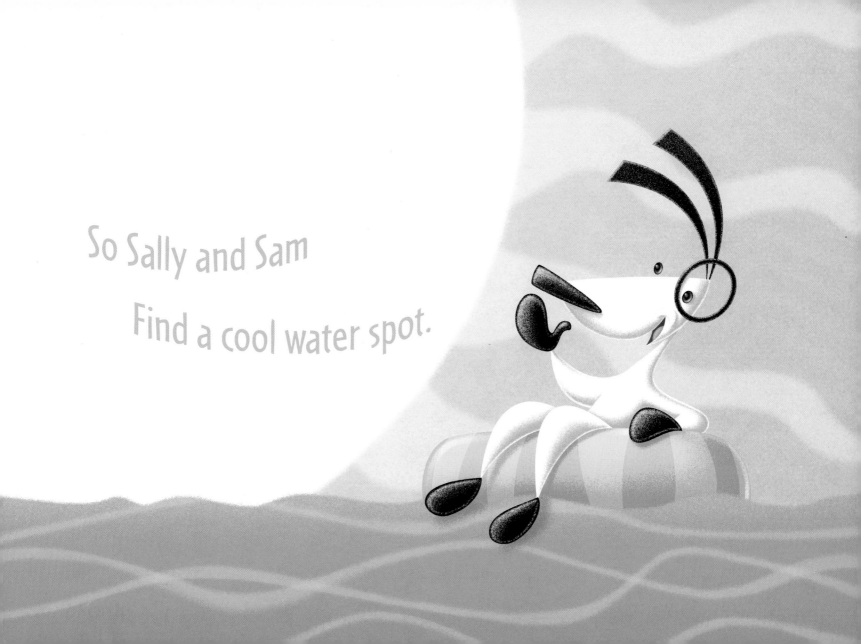

So Sally and Sam
Find a cool water spot.

The two of them find that nothing competes

With ice cream that's topped with the tastiest treats.

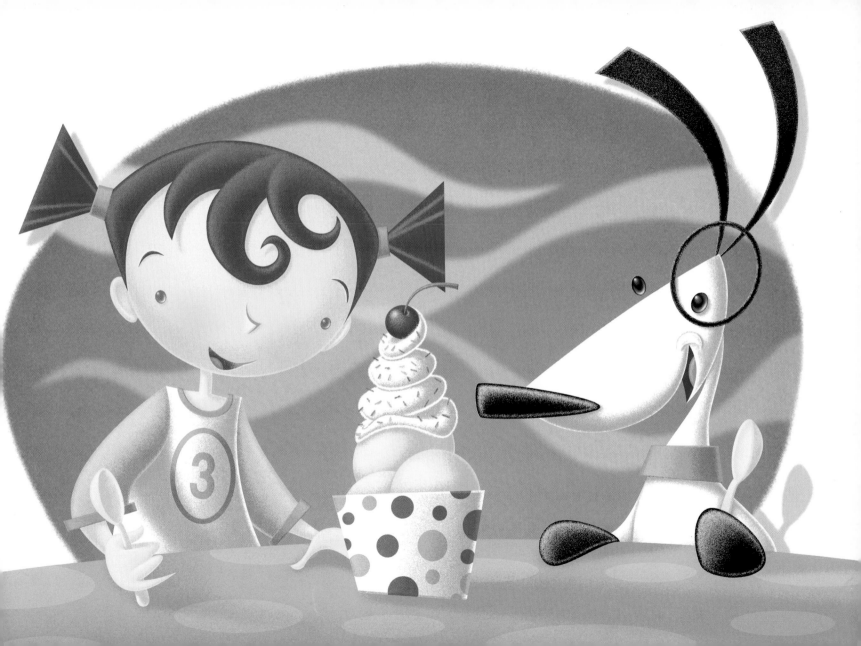

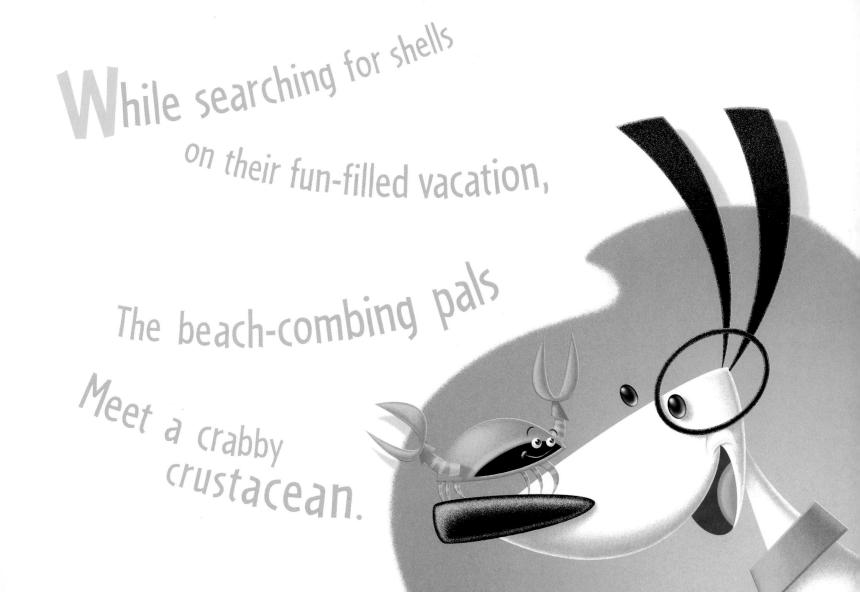

While searching for shells
on their fun-filled vacation,

The beach-combing pals

Meet a crabby
crustacean.

With shovels and buckets
(and sunscreen galore),

They build a great castle
Right there on the shore.

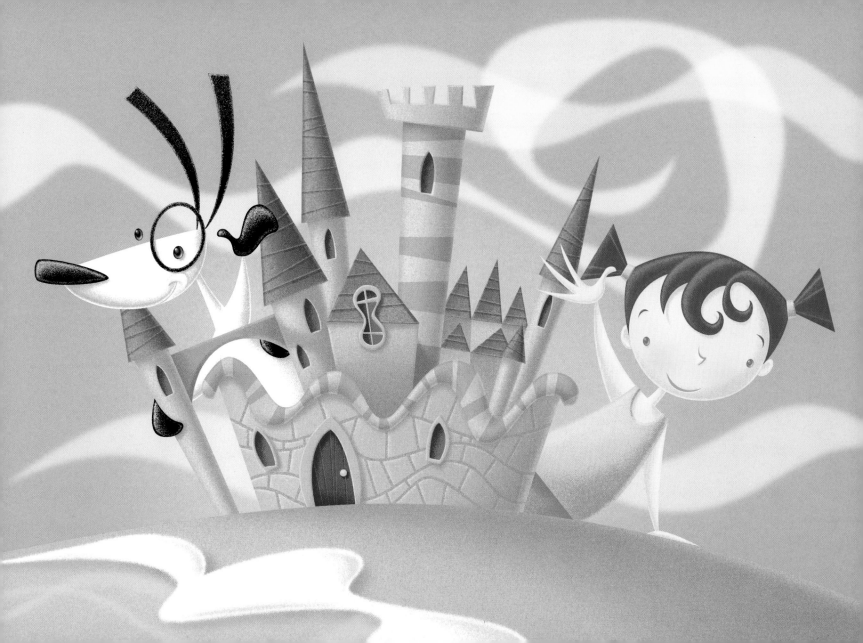

Sugar and water
And lemons in hand,

They open
"Le Groovy Lemonade" stand.

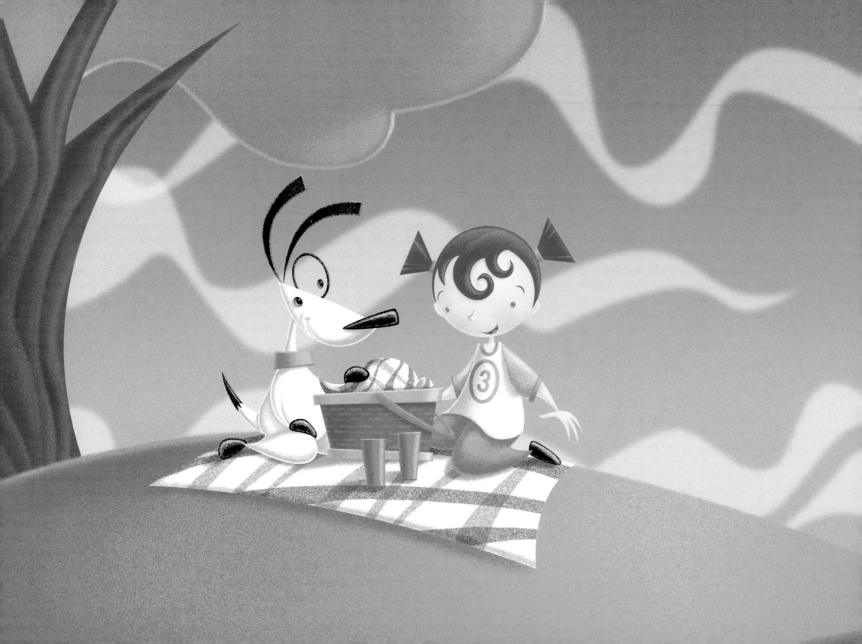

The two of them search for the best place to munch,
Their basket of goodies all packed with a lunch.

They think a great place would be under a tree,

Until they are joined by an ant jubilee.

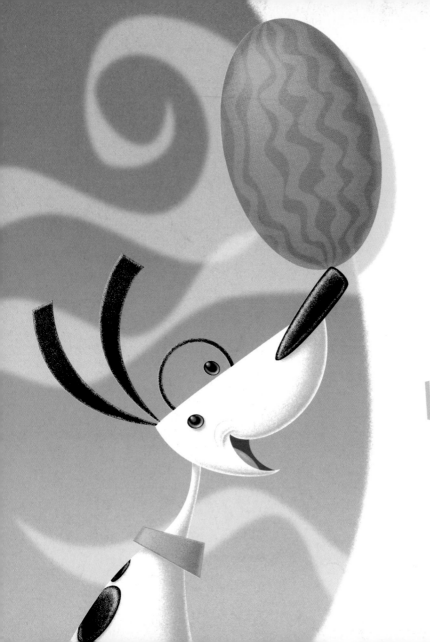

A fruity explosion
Is what they next find,

When eating a melon
Right off of the rind.

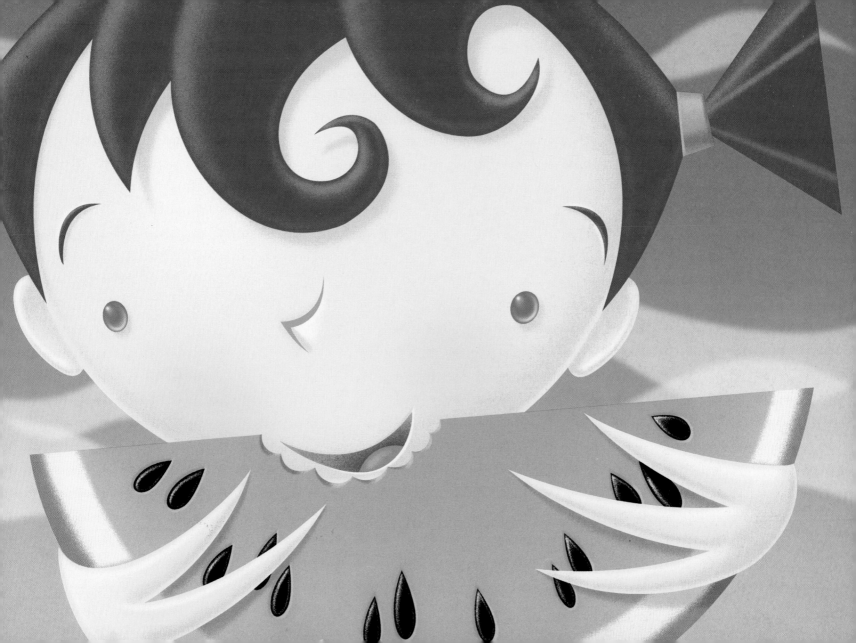

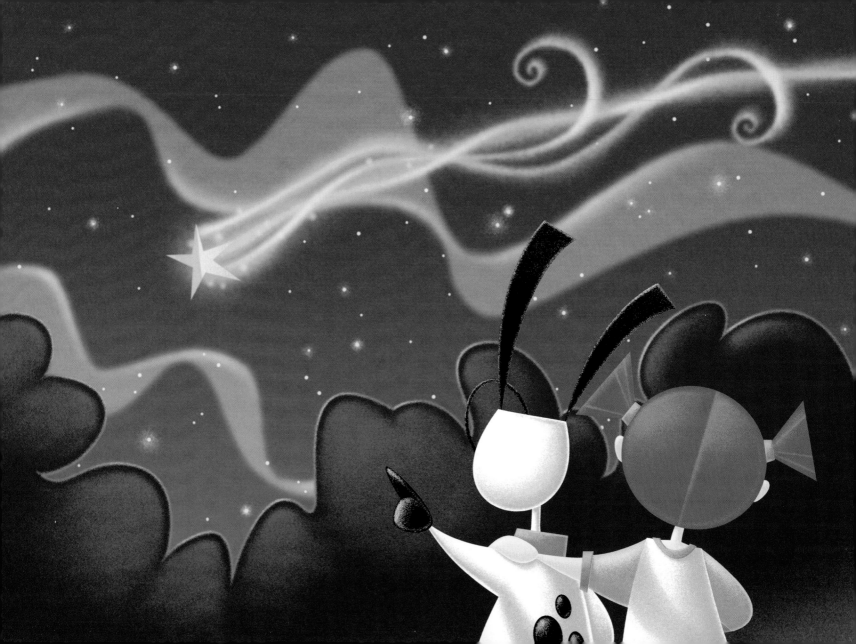

Imagine the thrill

And the utter delight

Of bright shooting stars

On a warm Summer's night.

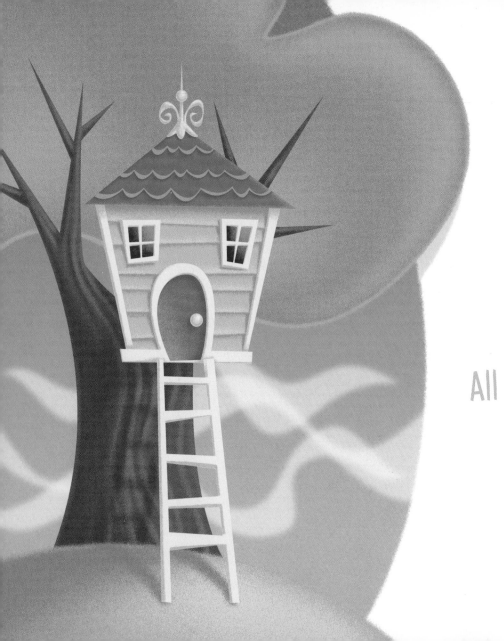

Then Sally and Sam
Take a break for some tea,

All snug in their clubhouse
High up in a tree.

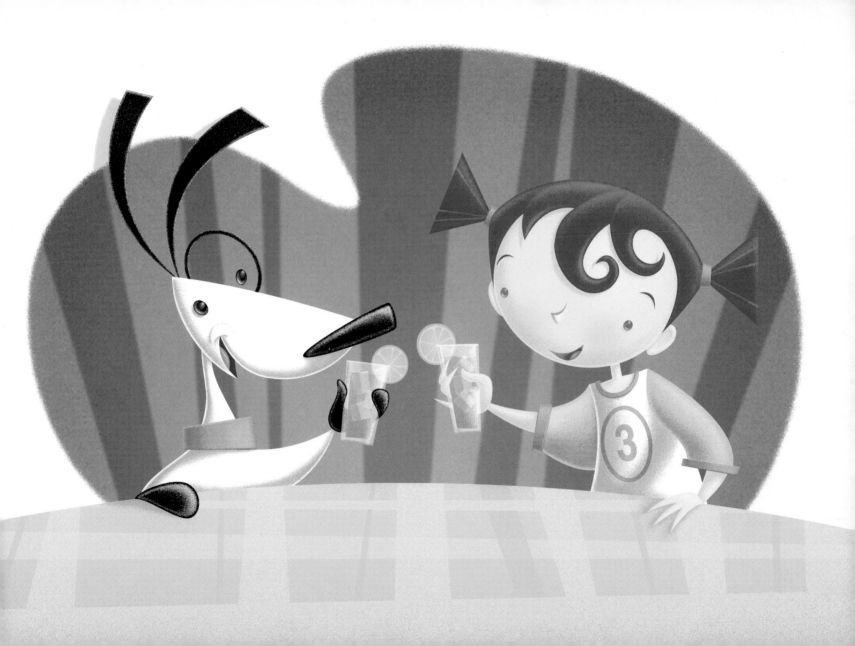

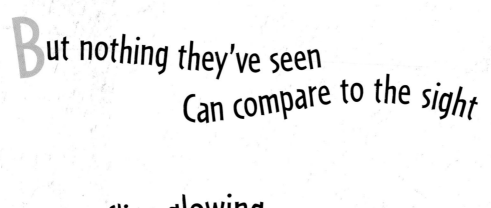

But nothing they've seen
Can compare to the sight

Of fireflies glowing
With magical light.

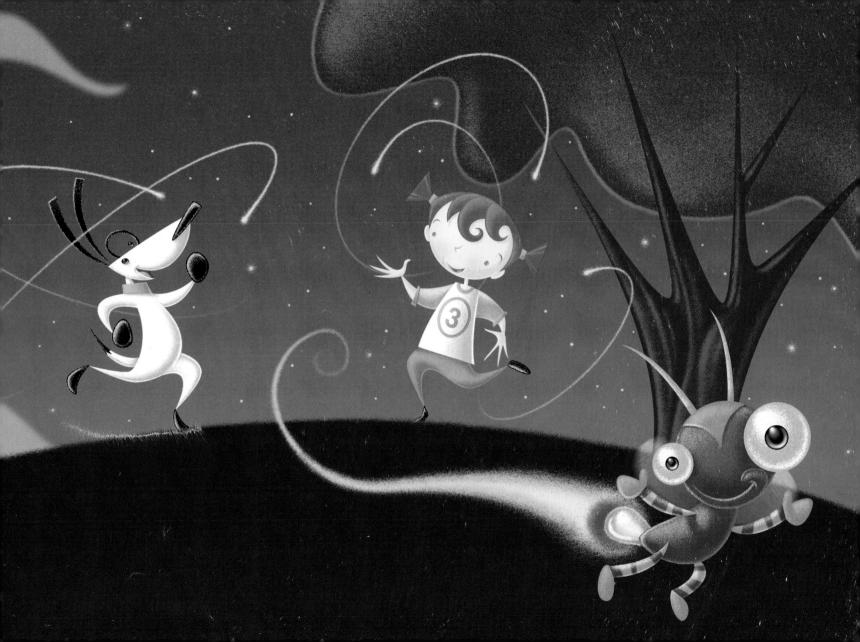

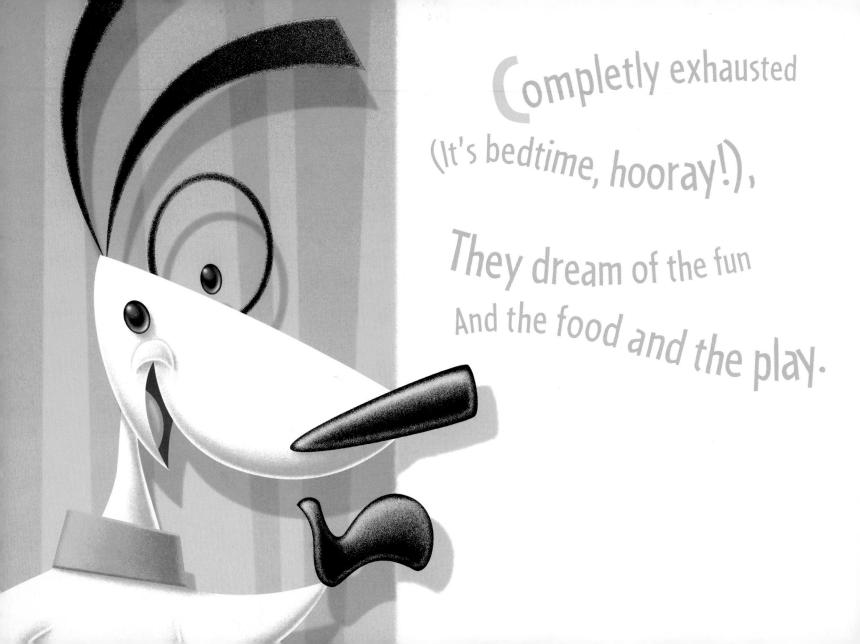

Completly exhausted
(It's bedtime, hooray!),

They dream of the fun
And the food and the play.

They know that tomorrow
will show them the way

To soak up the joy
Of a new Summer's day.

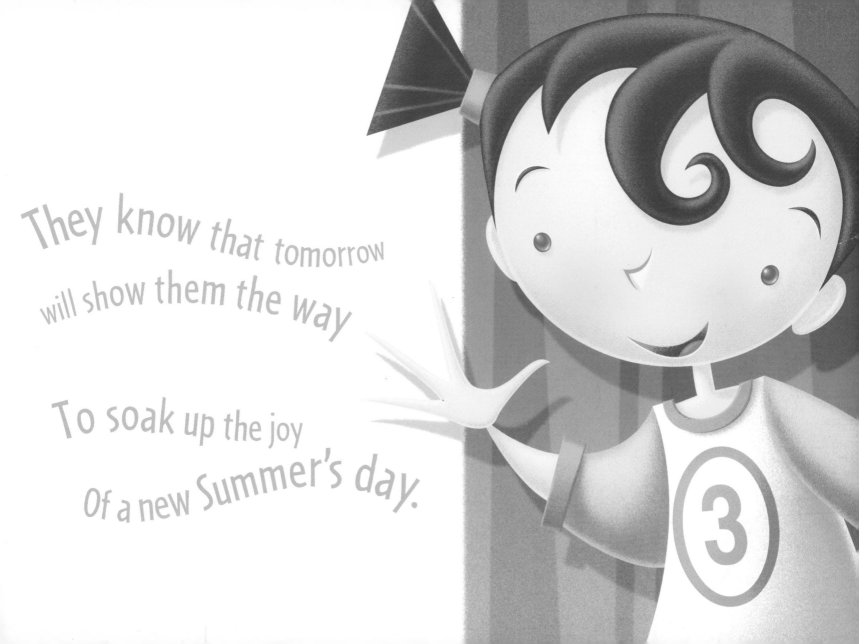

Published by
smallfellow press
A division of Tallfellow Press, Inc.
1180 S. Beverly Drive
Los Angeles, CA 90035

Type and Layout: Scott Allen

ISBN 1-931290-23-7

Printed in Italy
10 9 8 7 6 5 4 3 2 1

Tallfellow Press, Inc
Los Angeles